ELEGIES

OF LOVE

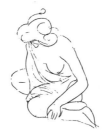

ELEGIES OF LOVE

by OVID *translated by*

MARLOWE *and*

illustrated by RODIN

PALLAS ATHENE

ELEGIES

ELEGY I

How he is obliged by Cupid to
write of love instead of war

Muse upreared I meant to sing of arms,
Choosing a subject fit for fierce alarms:
Both verses were alike till Love (men say)
Began to smile and took one foot away.
Rash boy, who gave thee power to change a line?
We are the Muses' prophets, none of thine.
What if thy Mother take Diana's bow,
Shall Dian fan when love begins to glow?
In woody groves is't meet that Ceres reign,
And quiver-bearing Dian till the plain:
Who'll set the fair tressed sun in battle ray,
While Mars doth take the Aonian harp to play?
Great are thy kingdoms, over-strong and large,
Ambitious imp, why seek'st thou further charge?
Are all things thine? The Muses' Tempe thine?
Then scarce can Phœbus say, this harp is mine.
When in this work's first verse I trod aloft,
Love slacked my Muse, and made my numbers soft.
I have no mistress, nor no favourite,
Being fittest matter for a wanton wit,
Thus I complained, but Love unlocked his quiver,
Took out the shaft, ordained my heart to shiver:
And bent his sinewy bow upon his knee,
Saying, 'Poet here's a work beseeming thee.'
Oh woe is me, he never shoots but hits,
I burn, Love in my idle bosom sits.
Let my first verse be six, my last five feet,
Farewell stern war, for blunter poets meet.

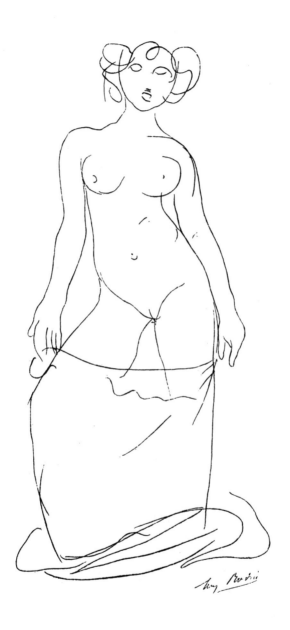

Elegian Muse, that warblest amorous lays,
Girt my shine brow with sea-bank myrtle praise.

*That, being carried away by first love, he suffers
himself to be led in triumph by Cupid*

What makes my bed seem hard, seeing it is soft?
Or why slips down the coverlet so oft?
Although the nights be long, I sleep not though
My sides are sore with tumbling to and fro.
Were Love the cause, it's like I should descry him,
Or lies he close, and shoots where none can spy him?
'Twas so, he stroke me with a slender dart,
'Tis cruel love turmoils my captive heart.
Yielding or striving do we give him might,
Let's yield, a burden eas'ly borne is light.
I saw a brandished fire increase in strength,
Which being not shaked, I saw it die at length.
Young oxen newly yoked are beaten more,
Than oxen which have drawn the plough before.
And rough jades' mouths with stubborn bits are torn,
But managed horses' heads are lightly borne,
Unwilling lovers, love doth more torment,
Than such as in their bondage feel content.
Lo I confess, I am thy captive I,
And hold my conquered hands for thee to tie.
What needs thou war, I sue to thee for grace,
With arms to conquer armless men is base,

Yoke Venus' doves, put myrtle on thy hair,
Vulcan will give thee chariots rich and fair.
The people thee applauding thou shalt stand,
Guiding the harmless pigeons with thy hand.
Young men and women, shalt thou lead as thrall,
So will thy triumph seem magnifical.
I lately caught, will have a new-made wound,
And captive-like be manacled and bound.
Good meaning, shame, and such as seek Love's wrack
Shall follow thee, their hands tied at their back.
Thee all shall fear and worship as a King,
Jo, triumphing shall thy people sing.
Smooth speeches, fear and rage shall by thee ride,
Which troops hath always been on Cupid's side:
Thou with these soldiers conquerest gods and men,
Take these away, where is thy honour then?
Thy mother shall from heaven applaud this show,
And on their faces heaps of roses strow.

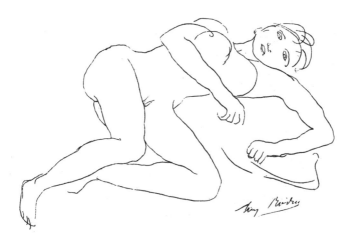

With beauty of thy wings, thy fair hair gilded,
Ride golden Love in chariots richly builded.
Unless I err, full many shalt thou burn,
And give wounds infinite at every turn.
In spite of thee, forth will thy arrows fly,
A scorching flame burns all the standers-by.
So, having conquered Inde, was Bacchus' hue,
Thee pompous birds and him two tigers drew.
Then seeing I grace thy show in following thee,
Forbear to hurt thyself in spoiling me.
Behold thy kinsman's Cæsar's prosperous bands,
Who guards the conquered with his conquering hands.

ELEGY 3

To his mistress

I ask but right: let her that caught me late,
Either love, or cause that I may never hate:
I ask too much, would she but let me love her,
Love knows with such like prayers, I daily move her:
Accept him that will serve thee all his youth,
Accept him that will love with spotless truth:
If lofty titles cannot make me thine,
That am descended but of knightly line,
(Soon may you plough the little lands I have,
I gladly grant my parents given to save),
Apollo, Bacchus, and the Muses may,
And Cupid who hath marked me for thy prey,
My spotless life, which but to gods gives place,

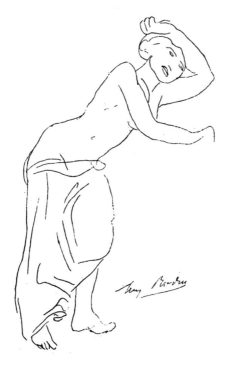

Naked simplicity, and modest grace.
I love but one, and her I love change never,
If men have faith, I'll live with thee forever.
The years that fatal destiny shall give,
I'll live with thee, and die, or thou shalt grieve.
Be thou the happy subject of my books,
That I may write things worthy thy fair looks:
By verses horned Io got her name,
And she to whom in shape of swan Jove came.
And she that on a feign'd bull swam to land,
Griping his false horns with her virgin hand:
So likewise we will through the world be rung,
And with my name shall thine be always sung.

ELEGY 4

*He advises his mistress what stratagem or nods she
should employ at dinner in her husband's presence*

Thy husband to a banquet goes with me,
Pray God it may his latest supper be,
Shall I sit gazing as a bashful guest,
While others touch the damsel I love best?
Wilt, lying under him, his bosom clip?
About thy neck shall he at pleasure skip?
Marvel not though the fair bride did incite
The drunken Centaurs to a sudden fight.
I am no half horse, nor in woods I dwell,
Yet scarce my hands from thee contain I well.
But how thou shouldst behave thyself now know;
Nor let the winds away my warnings blow.
Before thy husband come, though I not see
What may be done, yet there before him be.
Lie with him gently, when his limbs he spread
Upon the bed, but on my foot first tread.
View me, my becks, and speaking countenance:
Take, and receive each secret amorous glance.
Words without voice shall on my eyebrows sit,
Lines thou shalt read in wine by my hand writ.
When our lascivious toys come in thy mind,
Thy rosy cheeks be to thy thumb inclined.
If aught of me thou speak'st in inward thought,
Let thy soft finger to thy ear be brought.
When I (my light) do or say aught that please thee,
Turn round thy gold-ring, as it were to ease thee.
Strike on the board like them that pray for evil,
When thou dost wish thy husband at the devil.

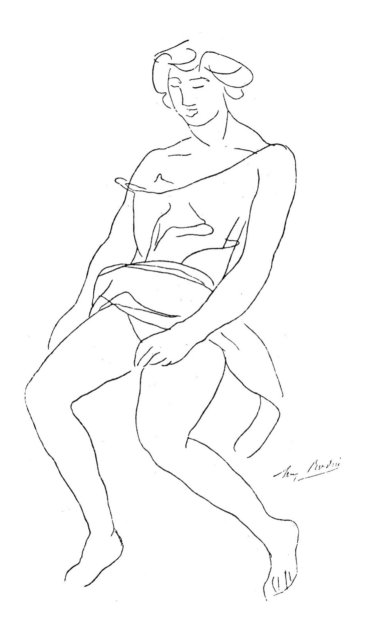

What wine he fills thee, wisely will him drink,
Ask thou the boy, what thou enough dost think.
When thou hast tasted, I will take the cup,
And where thou drink'st, on that part I will sup.
If he gives thee what first himself did taste,
Even in his face his offered gobbets cast.
Let not thy neck by his vile arms be pressed,
Nor lean thy soft head on his boisterous breast.
Thy bosom's roseate buds let him not finger,
Chiefly on thy lips let not his lips linger.
If thou givest kisses, I shall all disclose,
Say they are mine, and hands on thee impose.
Yet this I'll see, but if thy gown aught cover,
Suspicious fear in all my veins will hover,
Mingle not thighs, nor to his leg join thine,
Nor thy soft foot with his hard foot combine.
I have been wanton, therefore am perplexed,
And with mistrust of the like measure vexed.
I and my wench oft under clothes did lurk,
When pleasure mov'd us to our sweetest work.
Do not thou so, but throw thy mantle hence,
Lest I should think thee guilty of offence.
Entreat thy husband drink, but do not kiss,
And while he drinks, to add more do not miss,
If he lies down, with wine and sleep oppressed,
The thing and place shall counsel us the rest.
When to go homewards we rise all along,
Have care to walk in middle of the throng.
There will I find thee, or be found by thee,
There touch whatever thou canst touch of me.
Aye me, I warn what profits some few hours,
But we must part, when heav'n with black night lours.
At night thy husband clips thee, I will weep

And to the doors sight of thyself will keep:
Then will he kiss thee, and not only kiss
But force thee give him my stol'n honey bliss.
Constrain'd against thy will, give it the peasant,
Forbear sweet words, and be your sport unpleasant.
To him I pray it no delight may bring,
Or if it do, to thee no joy thence spring:
But though this night thy fortune be to try it,
To me tomorrow constantly deny it.

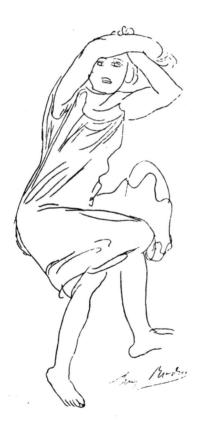

ELEGY 5

Going to bed with Corinna

In summer's heat, and mid-time of the day,
To rest my limbs, upon a bed I lay,
One window shut, the other open stood,
Which gave such light, as twinkles in a wood,
Like twilight glimpse at setting of the sun,
Or night being past, and yet not day begun.
Such light to shamefast maidens must be shown,
Where they may sport, and seem to be unknown.
Then came Corinna in a long loose gown,
Her white neck hid with tresses hanging down,
Resembling fair Semiramis going to bed,
Or Lais of a thousand lovers sped.
I snatched her gown: being thin, the harm was small,
Yet strived she to be covered therewithal,
And striving thus as one that would be cast,
Betrayed herself, and yielded at the last.
Stark naked as she stood before mine eye,
Not one wen in her body could I spy,
What arms and shoulders did I touch and see,
How apt her breasts were to be pressed by me,
How smooth a belly, under her waist saw I,
How large a leg, and what a lusty thigh?
To leave the rest, all liked me passing well,
I clinged her naked body, down she fell,
Judge you the rest, being tired she bade me kiss.
Jove send me more such afternoons as this.

ELEGY 6

To the porter, to open the door for him

Unworthy porter, bound in chains full sore,
On moved hooks set ope the churlish door.
Little I ask, a little entrance make,
The gate half ope my bent side in will take.
Long love my body to such use makes slender
And to get out doth like apt members render.
He shows me how unheard to pass the watch,
And guides my feet lest stumbling falls they catch.
But in times past I fear'd vain shades, and night,
Wond'ring if any walked without light.
Love hearing it laugh'd with his tender mother
And smiling said 'Be thou as bold as other'.
Forthwith Love came, no dark night-flying spright
Nor hands prepar'd to slaughter, me affright.
Thee fear I too much: only thee I flatter,
Thy lightning can my life in pieces batter.
Why enviest me, this hostile den unbar,
See how the gates with my tears wat'red are.
When thou stood'st naked ready to be beat,
For thee I did thy mistress fair entreat.
But what entreats for thee sometimes took place,
(O mischief) now for me obtain small grace.
Gratis thou mayst be free, give like for like,
Night goes away: the door's bar backward strike.
Strike, so again hard chains shall bind thee never,
Nor servile water shalt thou drink for ever.
Hard-hearted Porter dost and wilt not hear?
With stiff oak propp'd the gate doth still appear.
Such rampir'd gates besieged cities aid,

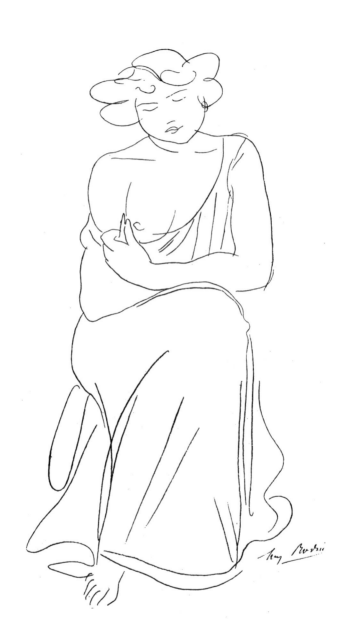

In midst of peace why art of arms afraid?
Exclud'st a lover, how would'st use a foe?
Strike back the bar, night fast away doth go.
With arms or armed men I come not guarded,
I am alone, were furious Love discarded.
Although I would, I cannot him cashier
Before I be divided from my gear.
See Love with me, wine moderate in my brain,
And on my hairs a crown of flowers remain.
Who fears these arms? Who will not go to meet them?
Night runs away; with open entrance greet them.
Art careless? Or is't sleep forbids thee hear,
Giving the winds my words running in thine ear?
Well I remember when I first did hire thee,
Watching till after mid-night did not tire thee.
But now perchance thy wench with thee doth rest,
Ah how thy lot is above my lot blest:
Though it be so, shut me not out therefore,
Night goes away: I pray thee ope the door.
Err we? Or do the turned hinges sound,
And opening doors with creaking noise abound?
We err: a strong blast seem'd the gates to ope:
Ay me how high that gale did lift my hope!
If Boreas bears Orithya's rape in mind,
Come break these deaf doors with thy boisterous wind.
Silent the city is: night's dewy host
March fast away: the bar strike from the post.
Or I more stern than fire or sword will turn,
And with my brand these gorgeous houses burn.
Night, Love, and wine to all extremes persuade:
Night shameless, wine and love are fearless made.
All have I spent: no threats or prayers move thee,
O harder than the doors thou gard'st I prove thee.

No pretty wench's keeper mayst thou be:
The careful prison is more meet for thee.
Now frosty night her flight begins to take,
And crowing cocks poor souls to work awake.
But thou my crown, from sad hairs ta'en away,
On this hard threshold till the morning lay.
That when my mistress there beholds thee cast,
She may perceive how we the time did waste:
What ere thou art, farewell, be like me pained,
Careless, farewell, with my fault not distained.
And farewell cruel posts, rough threshold's block,
And doors conjoined with an hard iron lock.

ELEGY 7

*To placate his mistress,
whom he had beaten*

Bind fast my hands, they have deserved chains,
While rage is absent, take some friend the pains.
For rage against my wench mov'd my rash arm,
My mistress weeps whom my mad hand did harm.
 I might have then my parents dear misus'd,
Or holy gods with cruel strokes abus'd.
Why? Ajax, master of the seven-fold shield,
Butcher'd the flocks he found in spacious field,
And he who on his mother veng'd his sire,
Against the Destinies durst sharp darts require.
Could I therefore her comely tresses tear?
Yet was she graced with her ruffled hair.

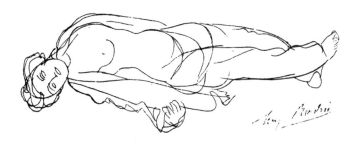

So fair she was, Atalanta she resembled,
 Before whose bow th'Arcadian wild beasts trembled.
 Such Ariadne was, when she bewails
Her perjur'd Theseus' flying vows and sails,
So chaste Minerva did Cassandra fall,
Deflowr'd except, within thy Temple wall.
That I was mad and barbarous all men cried,
She nothing said, pale fear her tongue had tied.
But secretly her looks with checks did trounce me,
Her tears, she silent, guilty did pronounce me.
Would of mine arms, my shoulders had been scanted,
Better I could part of my self have wanted.
To mine own self have I had strength so furious?
And to my self could I be so injurious?
Slaughter and mischiefs instruments, no better,
Deserved chains these cursed hands shall fetter,
Punished I am, if I a Roman beat,
Over my mistress is my right more great?
Tydides left worst signs of villainy,
He first a goddess strook; another I.
Yet he harrn'd less, whom I profess'd to love,
I harm'd: a foe did Diomedes anger move.
Go now thou conqueror, glorious triumphs raise,
Pay vows to Jove, engirt thy hairs with bays,
And let the troops which shall thy chariot follow,

'Jo, a strong man conquer'd this wench,' hollo.
Let the sad captive foremost with locks spread
On her white neck but for hurt cheeks be led.
Meeter it were her lips were blue with kissing
And on her neck a wanton's mark not missing.
But though I like a swelling flood was driven,
And as a pray unto blind anger given,
Was't not enough the fearful wench to chide?
Nor thunder in rough threatings haughty pride?
Nor shamefully her coat pull o'er her crown,
Which to her waist her girdle still kept down.
But cruelly her tresses having rent,
My nails to scratch her lovely cheeks I bent.
Sighing she stood, her bloodless white looks shewed
Like marble from the Parian Mountains hewed.
Her half dead joints, and trembling limbs I saw,
Like poplar leaves blown with a stormy flaw,

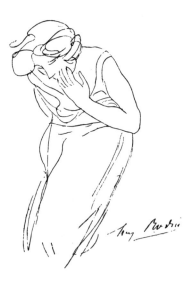

Or slender ears, with gentle zephyr shaken,
Or waters' tops with the warm south-wind taken.
And down her cheeks, the trickling tears did flow,
Like water gushing from consuming snow.
Then first I did perceive I had offended,
My blood, the tears were that from her descended.
Before her feet thrice prostrate down I fell,
My feared hands thrice back she did repel.
But doubt thou not (revenge doth grief appease)
With thy sharp nails upon my face to seize.
Bescratch mine eyes, spare not my locks to break,
(Anger will help thy hands though ne'er so weak).
And lest the sad signs of my crime remain,
Put in their place thy combed hairs again.

ELEGY 8

*He curses the bawd who has been instructing
his mistress in the arts of a whore*

There is, whoe'er will know a bawd aright
Give ear, there is an old trot, Dipsas hight.
Her name comes from the thing: she being wise,
Sees not the morn on rosy horses rise.
She magic arts and Thessale charms doth know,
And makes large streams back to their fountains flow,
She knows with grass, with threads on wrong wheels spun
And what with mares' rank humour may be done.
When she will, clouds the darken'd heav'n obscure,
When she will, day shines everywhere most pure.

(If I have faith) I saw the stars drop blood,
The purple moon with sanguine visage stood.
Her I suspect among nights spirits to fly,
And her old body in birds' plumes to lie.
Fame saith as I suspect, and in her eyes
Two eye-balls shine, and double light thence flies.
Great grand-sires from their ancient graves she chides
And with long charms the solid earth divides.
She draws chaste women to incontinence,
Nor doth her tongue want harmful eloquence.
By chance I heard her talk, these words she said
While closely hid betwixt two doors I laid.
'Mistress thou know'st, thou hast a blest youth pleas'd,
He stayed, and on thy looks his gazes seiz'd.
And why shouldst not please? None thy face exceeds,
Ay me, thy body hath no worthy weeds.
As thou art fair, would thou wert fortunate,
Wert thou rich, poor should not be my estate.
Th'opposed star of Mars hath done thee harm,
Now Mars is gone: Venus thy side doth warm,
And brings good fortune, a rich lover plants
His love on thee, and can supply thy wants.
Such is his form as may with thine compare,
Would he not buy thee thou for him should'st care.'
She blushed: 'Red shame becomes white cheeks, but this
If feigned, doth well; if true it doth amiss.
When on thy lap thine eyes thou dost deject,
Each one according to his gifts respect.
Perhaps the Sabines rude, when Tatius reigned,
To yield their love to more then one disdained.
Now Mars doth rage abroad without all pity,
And Venus rules in her Aeneas' city.
Fair women play, she's chaste whom none will have,

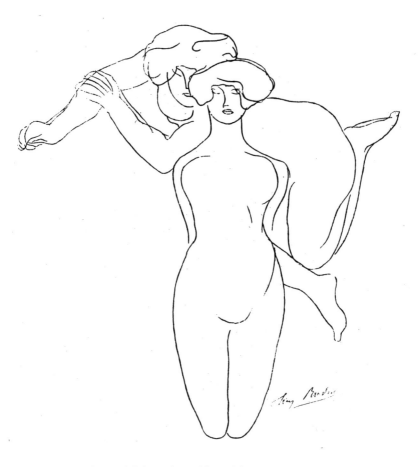

Or, but for bashfulness herself would crave.
Shake off these wrinkles that thy front assault,
Wrinkles in beauty is a grievous fault.
Penelope in bows her youths' strength tried,
Of horn the bow was that approv'd their side.
Time flying slides hence closely, and deceives us,
And with swift horses the swift year soon leaves us.
Brass shines with use; good garments would be worn,

Houses not dwelt in, are with filth forlorn.
Beauty not exercised with age is spent,
Nor one or two men are sufficient.
Many to rob is more sure, and less hateful,
From dog-kept flocks come preys to wolves most grateful.
Behold what gives the poet but new verses?
And thereof many thousand he rehearses.
The poets' God arrayed in robes of gold,
Of his gilt harp the well tun'd strings doth hold.
Let Homer yield to such as presents bring,
(Trust me) to give, it is a witty thing.
Nor, so thou mayst obtain a wealthy prize,
The vain name of inferior slaves despise.
Nor let the arms of ancient lines beguile thee,
Poor lover with thy grandsires I exile thee.
Who seeks, for being fair, a night to have,
What he will give, with greater instance crave.
Make a small price, while thou thy nets dost lay,
Lest they should fly, being ta'en, the tyrant play.
Dissemble so, as lov'd he may be thought,
And take heed lest he gets that love for naught.
Deny him oft, feign now thy head doth ache:
And Isis now will show what 'scuse to make.
Receive him soon, lest patient use he gain,
Or lest his love oft beaten back should wain.
To beggars shut, to bringers ope thy gate,
Let him within hear barr'd-out lovers prate.
And as first wrong'd the wronged sometimes banish,
Thy fault with his fault so repuls'd will vanish.
But never give a spacious time to ire,
Anger delayed doth oft to hate retire.
And let thine eyes constrained learn to weep,
That this, or that man may thy cheeks moist keep.

Nor, if thou cozen'st one, dread to forswear,
Venus to mocked men lends a senseless ear.
Servants fit for thy purpose thou must hire
To teach thy lover, what thy thoughts desire.
Let them ask somewhat, many asking little,
Within a while great heaps grow of a tittle.
And sister, nurse, and mother spare him not,
By many hands great wealth is quickly got.
When causes fail thee to require a gift,
By keeping of thy birth make but a shift.
Beware lest he unrival'd loves secure,
Take strife away, love doth not well endure.
On all the bed men's tumbling let him view
And thy neck with lascivious marks made blue.
Chiefly shew him the gifts, which others send:
If he gives nothing, let him from thee wend.
When thou hast so much as he gives no more,
Pray him to lend what thou mayst ne'er restore.
Let thy tongue flatter, while thy mind harm works:

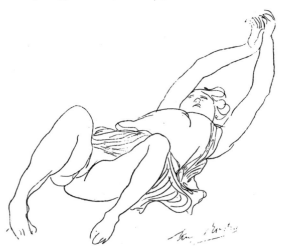

Under sweet honey deadly poison lurks.
If this thou dost, to me by long use known,
Nor let my words be with the winds hence blown,
Oft thou wilt say, live well, thou wilt pray oft,
That my dead bones may in their grave lie soft.'
As thus she spake, my shadow me betrayed,
With much ado my hands I scarcely stay'd.
But her blear eyes, bald scalp's thin hoary fleeces
And rivell'd cheeks I would have pull'd a-pieces.
The gods send thee no house, a poor old age,
Perpetual thirst, and winter's lasting rage.

ELEGY 9

*To Atticus, that a lover ought not to be
lazy any more than a soldier*

All lovers war, and Cupid hath his tent,
Attic, all lovers are to war far sent.
What age fits Mars, with Venus doth agree,
'Tis shame for eld in war or love to be.
What years in soldiers' captains do require,
Those in their lovers, pretty maids desire.
Both of them watch: each on the hard earth sleeps:
His mistress 'dores this; that his captain's keeps.
Soldiers must travail far: the wench forth send,
Her valiant lover follows without end.
Mounts, and rain-doubled floods he passeth over,
And treads the desert's snowy heaps do cover.
Going to sea, east winds he doth not chide

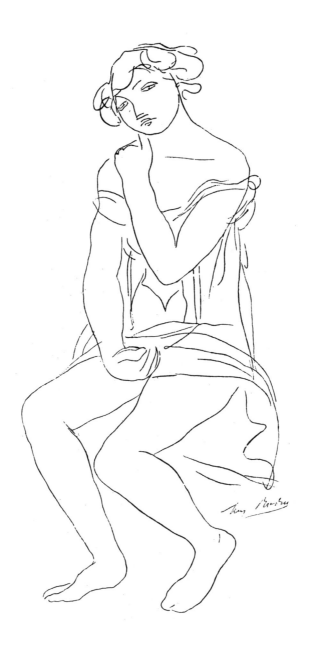

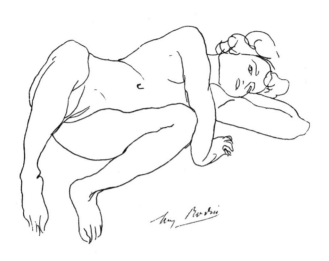

Nor to hoist sail attends fit time and tide.
Who but a soldier or a lover is bold
To suffer storm-mixed snows with night's sharp cold?
One as a spy doth to his enemies go,
The other eyes his rival as his foe.
He cities great, this thresholds lies before:
This breaks town gates, but he his mistress' door.
Oft to invade the sleeping foe 'tis good
And arm'd to shed unarmed peoples' blood.
So the fierce troops of Thracian Rhesus fell
And captive horses bade their Lord farewell.
Sooth lovers watch till sleep the husband charms,
Who slumb'ring, they rise up in swelling arms.
The keeper's hands and corps-du-gard to pass
The soldiers, and poor lovers work e'er was.
Doubtful is war and love, the vanquish'd rise
And who thou never think'st should fall down lies.
Therefore whoe'er love slothfulness doth call,
Let him surcease: love tries wit best of all.

Achilles burn'd Briseis being ta'en away:
Trojans destroy the Greek wealth, while you may.
Hector to arms went from his wife's embraces,
And on Andromache his helmet laces.
Great Agamemnon was, men say, amazed,
On Priam's loose-tress'd daughter when he gazed.
Mars in the deed the blacksmith's net did stable,
In heav'n was never more notorious fable.
Myself was dull, and faint, to sloth inclined,
Pleasure, and ease had mollified my mind.
A fair maid's care expell'd this sluggishness,
And to her tents wild me myself address.
Since mayst thou see me watch and night wars move:
He that will not grow slothful, let him love.

ELEGY 10

*To a girl, not to ask for
reward for love*

Such as the cause was of two husbands' war,
Whom Trojan ships fetch'd from Europa far.
Such as was Leda, whom the God deluded
In snow-white plumes of a false swan included.
Such as Amimone through the dry fields strayed
When on her head a water pitcher layed.
Such wert thou, and I fear'd the bull and eagle
And whate'er love made Jove should thee inveigle.
Now all fear with my mind's hot love abates,
No more this beauty mine eyes captivates.

Ask'st why I change? Because thou crav'st reward:
This cause hath thee from pleasing me debarr'd.
While thou wert plain, I lov'd thy mind and face:
Now inward faults thy outward form disgrace.
Love is a naked boy, his years sans stain,
And hath no clothes, but open doth remain.
Will you for gain have Cupid sell himself?
He hath no bosom, where to hide base pelf.
Love and Love's son are with fierce arms to odds;
To serve for pay beseems not wanton gods.
The whore stands to be bought for each man's money
And seeks vilde wealth by selling of her coney,
Yet greedy bawds command she curseth still,
And doth constrain'd what you do of good will.
Take from irrational beasts a precedent,
'Tis shame their wits should be more excellent.
The mare asks not the horse, the cow the bull,
Nor the mild ewe gifts from the ram doth pull.
Only a woman gets spoils from a man,
Farms out herself on nights for what she can.
And lets what both delight, what both desire,
Making her joy according to her hire.
The sport being such, as both alike sweet try it,
Why should one sell it, and the other buy it?
Why should I lose, and thou gain by the pleasure
Which man and woman reap in equal measure?
Knights of the post of perjuries make sail,
The unjust judge for bribes becomes a stale.
'Tis shame sold tongues the guilty should defend
Or great wealth from a judgement seat ascend.
Tis shame to grow rich by bed merchandise,
Or prostitute thy beauty for bad prize.
Thanks worthily are due for things unbought,

For beds ill-hir'd we are indebted naught.
The hirer payeth all, his rent discharg'd
From further duty he rests then enlarg'd.
Fair dames forbear rewards for nights to crave,
Ill-gotten goods good end will never have.
The Sabine gauntlets were too dearly won
That unto death did press the holy nun.
The son slew her, that forth to meet him went,
And a rich necklace caus'd that punishment.
Yet think no scorn to ask a wealthy churl,
He wants no gifts into thy lap to hurl.
Take cluster'd grapes from an o'er-laden vine,
May bounteous loam Alcinous' fruit resign.
Let poor men show their service, faith, and care;
All for their mistress, what they have, prepare.
In verse to praise kind wenches 'tis my part,
And whom I like eternize by mine art.
Garments do wear, jewels and gold do waste,
The fame that verse gives doth for ever last.
To give I love, but to be ask'd disdain,
Leave asking, and I'll give what I refrain.

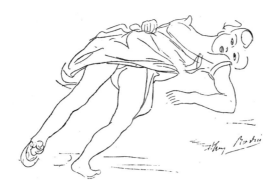

*He tells Nape to carry
a letter to Corinna*

In skilful gathering ruffled hairs in order,
Nape free-born, whose cunning hath no border,
Thy service for night's scapes is known commodious
And to give signs dull wit to thee is odious.
Corinna clips me oft by thy persuasion,
Never to harm me made thy faith evasion.
Receive these lines, them to my mistress carry,
Be sedulous, let no stay cause thee tarry.
Nor flint, nor iron, are in thy soft breast
But pure simplicity in thee doth rest.
And 'tis suppos'd Love's bow hath wounded thee,
Defend the ensigns of thy war in me.
If, what I do, she asks, say hope for night,

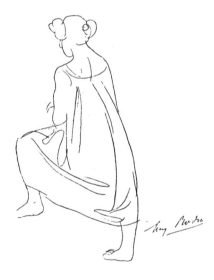

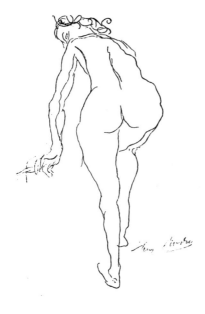

The rest my hand doth in my letters write.
Time passeth while I speak, give her my writ
But see that forthwith she peruseth it.
I charge thee mark her eyes and front in reading,
By speechless looks we guess at things succeeding.
Straight being read, will her to write much back,
I hate fair paper should writ matter lack.
Let her make verses, and some blotted letter
On the last edge to stay mine eyes the better.
What need she tire her hand to hold the quill,
Let this word, 'Come', alone the tables fill.
Then with triumphant laurel will I grace them
And in the midst of Venus' temple place them.
Subscribing that to her I consecrate
My faithful tables, being vile maple late.

ELEGY 12

He curses the letter which he had sent, because his mistress refused him the night

Bewail my chance, the sad book is return'd,
This day denial hath my sport adjourn'd.
Presages are not vain, when she departed
Nape, by stumbling on the threshold, started.
Going out again pass forth the door more wisely
And somewhat higher bear thy foot precisely.
Hence luckless tables, funeral wood be flying
And thou the wax stuff'd full with notes denying,
Which I think gather'd from cold hemlock's flower
Wherein bad honey Corsic bees did power.
Yet as if mixed with red lead thou wert ruddy,
That colour rightly did appear so bloody.
As evil wood thrown in the highways lie,
Be broke with wheels of chariots passing by.
And him that hew'd you out for needful uses
I'll prove had hands impure with all abuses.
Poor wretches on the tree themselves did strangle,
There sat the hangman for men's necks to angle.
To hoarse screech-owls foul shadows it allows,
Vultures and furies nestled in the boughs.
To these my love I foolishly committed
And then with sweet words to my mistress fitted.
More fitly had they wrangling bonds contain'd
From barbarous lips of some attorney strain'd.
Among day books and bills they had lame better
In which the merchant wails his bankrupt debtor.
Your name approves you made for such like things,
The number two no good divining brings.

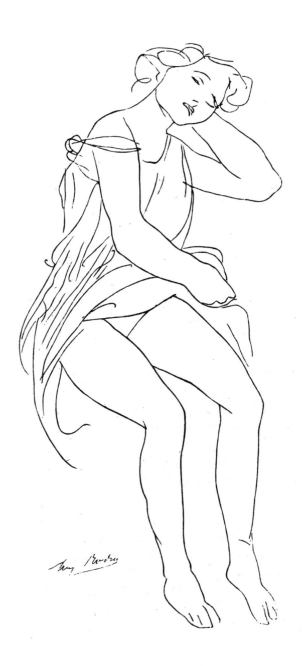

Angry, I pray that rotten age you wracks
And sluttish white-mould overgrow the wax.

ELEGY 13

To the Dawn, not to hurry

Now on the sea from her old love comes she,
That draws the day from heaven's cold axle-tree.
Aurora whither slid'st thou? Down again,
And birds for Memnon yearly shall be slain.
Now in her tender arms I sweetly bide,
If ever, now well lies she by my side.
The air is cold, and sleep is sweetest now,
And birds send forth shrill notes from every bough.
Whither runn'st thou, that men, and women, love not?
Hold in thy rosy horses that they move not.
Ere thou rise, stars teach seamen where to sail,
But when thou com'st they of their courses fail.
Poor travellers though tir'd, rise at thy sight,
And soldiers make them ready to the fight,
The painful hind by thee to field is sent,
Slow oxen early in the yoke are pent.
Thou cozen'st boys of sleep, and dost betray them
To pedants, that with cruel lashes pay them.
Thou mak'st the surety to the lawyer run,
That with one word hath nigh himself undone,
The lawyer and the client hate thy view,
Both whom thou raisest up to toil anew.
By thy means women of their rest are barr'd,

Thou sett'st their labouring hands to spin and card.
All could I bear, but that the wench should rise,
Who can endure, save him with whom none lies?
How oft wished I night would not give thee place,
Nor morning stars shun thy uprising face.
How oft, that either wind would break thy coach,
Or steeds might fall forc'd with thick clouds approach.
Whither goest thou, hateful nymph? Memnon the elf
Received his coal-black colour from thyself.
Say that thy love with Cephalus were not known,
Then thinkest thou thy loose life is not shown?
Would Tithon might but talk of thee awhile,
Not one in heav'n should be more base and vile.
Thou leav'st his bed, because he's faint through age,
And early mount'st thy hateful carriage:
But held'st thou in thine arms some Cephalus,
Then would'st thou cry, 'Stay night and run not thus'.
Punish ye me, because years make him wain?
I did not bid thee wed an aged swain.

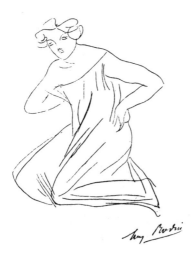

39

The moon sleeps with Endymion every day,
Thou art as fair as she, then kiss and play.
Jove, that thou should'st not haste but wait his leisure,
Made two nights one to finish up his pleasure.
I chid no more, she blush'd, and therefore heard me,
Yet linger'd not the day, but morning scar'd me.

ELEGY 14

That he is compelled to write of love-affairs,
rather than the battle of the Giants

I, Ovid, poet of my wantonness,
Born at Peligny, to write more address.
So Cupid wills, far hence be the severe,
You are unapt my looser lines to hear.
Let maids whom hot desire to husbands lead,
And rude boys touch'd with unknown love me read,
That some youth hurt as I am with Love's bow
His own flame's best acquainted signs may know,
And, long admiring, say by what means learn'd
Hath this same poet my sad chance discern'd?
I durst the great celestial battles tell,
Hundred-hand Gyges, and had done it well,
With earth's revenge and how Olympus' top
High Ossa bore, mount Pelion up to prop.
Jove and Jove's thunderbolts I had in hand
Which for his heav'n fell on the Giants' band.
My wench her door shut, Jove's affairs I left,
Even Jove himself out of my wit was reft.

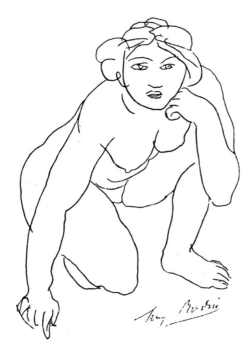

Pardon me Jove, thy weapons aid me naught,
Her shut gates greater lightning than thine brought.
Toys, and light elegies my darts I took,
Quickly soft words hard doors wide open strook.
Verses deduce the horned bloody moon
And call the sun's white horses back at noon.
Snakes leap by verse from caves of broken mountains
And turned streams run backward to their fountains.
Verses ope doors, and locks put in the post
Although of oak, to yield to verses boast.
What helps it me of fierce Achill to sing?
What good to me will either Ajax bring?
Or he who war'd and wand'red twenty year?
Or woeful Hector whom wild jades did tear ?

But when I praise a pretty wench's face
She in requital doth me oft embrace.
A great reward. Heroes of famous names
Farewell, your favour naught my mind inflames.
Wenches, apply your fair looks to my verse
Which golden love doth unto me rehearse.

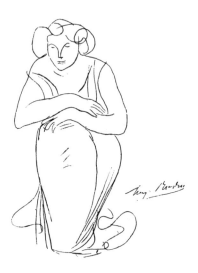

ELEGY 15

To Bagous, that he should keep watch with greater laxity over the girl committed to his charge

Bagous, whose care doth thy mistress bridle,
While I speak some few, yet fit, words, be idle.
I saw the damsel walking yesterday
There where the porch doth Danaus' fact display.
She pleas'd me, soon I sent, and did her woo,
Her trembling hand writ back she might not do.
And asking why, this answer she redoubled,
Because thy care too much thy mistress troubled.
Keeper, if thou be wise, cease hate to cherish,
Believe me, whom we fear, we wish to perish.
Nor is her husband wise, what needs defence
When unprotected there is no expense?
But furiously he follow his love's fire
And think her chaste whom many do desire.
Stol'n liberty she may by thee obtain,
Which, giving her, she may give thee again.
Wilt thou her fault learn, she may make thee tremble,
Fear to be guilty, then thou mayst dissemble.
Think when she reads, her mother letters sent her,
Let him go forth known, that unknown did enter,
Let him go see her though she do not languish
And then report her sick and full of anguish.
If long she stays, to think the time more short
Lay down thy forehead in thy lap to snort.
Enquire not what with Isis may be done
Nor fear lest she to the theatre's run.
Knowing her scapes thine honour shall increase,
And what less labour then to hold thy peace?

Let him please, haunt the house, be kindly us'd,
Enjoy the wench, let all else be refus'd.
Vain causes fame of him the true to hide,
And what she likes, let both hold ratified.
When most her husband bends the brows and frowns,
His fawning wench with her desire he crowns.
But yet sometimes to chide thee let her fall
Counterfeit tears: and thee lewd hangman call.
Object thou then what she may well excuse,
To stain all faith in truth, by false crimes use.
Of wealth and honour so shall grow thy heap,
Do this and soon thou shalt thy freedom reap.
On tell-tales necks thou seest the link-knit chains,
The filthy prison faithless breasts restrains.
Water in waters, and fruit flying touch
Tantalus seeks, his long tongue's game is such.
While Juno's watchman, Io, too much eyed,
Him timeless death took, she was deified.
I saw one's legs with fetters black and blue,
By whom the husband his wife's incest knew.
More he deserv'd, to both great harm he fram'd,
The man did grieve, the woman was defam'd.
Trust me, all husbands for such faults are sad
Nor make they any man that hear them glad.
If he loves not, deaf ears thou dost importune,
Or if he loves, thy tale breeds his misfortune.
Nor is it easily prov'd though manifest,
She safe by favour of her judge doth rest.
Though himself see; he'll credit her denial,
Condemn his eyes, and say there is no trial.
Spying his mistress' tears, he will lament
And say this blab shall suffer punishment.
Why fight'st 'gainst odds? To thee, being cast, do hap

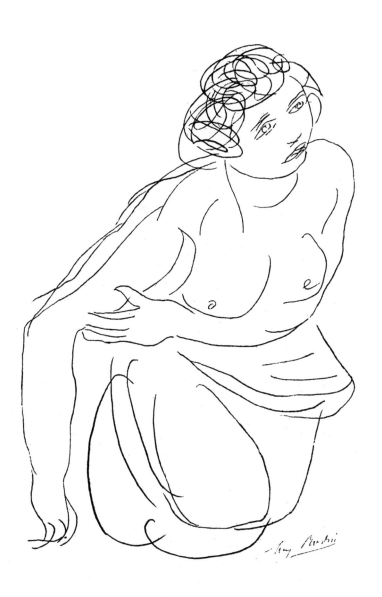

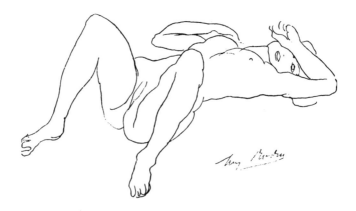

Sharp stripes, she sitteth in the judge's lap.
To meet for poison or vilde facts we crave not,
My hands an unsheath'd shining weapon have not.
We seek that through thee safely love we may,
What can be easier than the thing we pray?

ELEGY 16

To the eunuch house servant

Ay me, an Eunuch keeps my mistress chaste,
That cannot Venus' mutual pleasure taste.
Who first depriv'd young boys of their best part,
With selfsame wounds he gave, he ought to smart.
To kind requests thou would'st more gentle prove,
If ever wench had made luke-warm thy love:
Thou wert not born to ride, or arms to bear ,
Thy hands agree not with the warlike spear.

Men handle those, all manly hopes resign,
Thy mistress' ensigns must be likewise thine.
Please her, her hate makes others thee abhor,
If she discards thee, what use serv'st thou for?
Good form there is, years apt to play together,
Unmeet is beauty without use to wither.
She may deceive thee, though thou her protect,
What two determine never wants effect.
Our prayers move thee to assist our drift,
While thou hast time yet to bestow that gift.

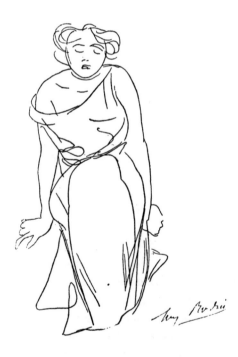

ELEGY 17

That he loves women, whatever their looks

I mean not to defend the scapes of any,
Or justify my vices being many,
For I confess, if that might merit favour,
Here I display my lewd and loose behaviour.
I loathe, yet after that I loathe, I run:
Oh how the burden irks, that we should shun.
I cannot rule myself, but where love please
Am driven like a ship upon rough seas,
No one face likes me best, all faces move,
A hundred reasons makes me ever love.
If any eye me with a modest look,
I burn, and by that blushful glance am took:
And she that's coy I like for being no clown,
Methinks she should be nimble when she's down.
Though her sour looks a Sabine's brow resemble,
I think she'll do, but deeply can dissemble.
If she be learned, then for her skill I crave her,
If not, because she's simple I would have her.
Before Callimachus one prefers me far,
Seeing she likes my books, why should we jar?
Another rails at me, and that I write,
Yet would I lie with her if that I might.
Trips she, it likes me well, plods she, what then?
She would be nimbler, lying with a man.
And when one sweetly sings, then straight I long,
To quaver on her lips ev'n in her song,
Or if one touch the lute with art and cunning,
Who would not love those hands for their swift running?
And she I like that with a majesty,

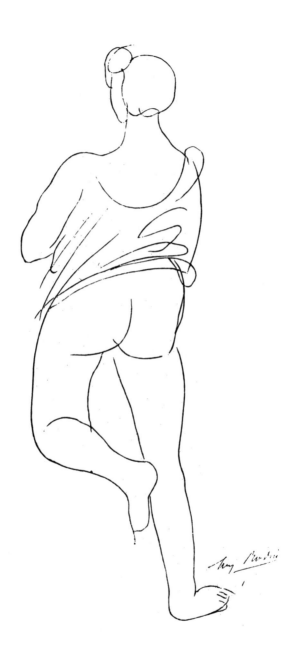

Folds up her arms, and makes low courtesy.
To leave myself, that am in love with all,
Some one of these might make the chastest fall.
If she be tall, she's like an Amazon,
And therefore fills the bed she lies upon:
If short, she lies the rounder: to speak troth,
Both short and long please me, for I love both:
I think what one undeckt would be, being dress'd;
Is she attired, then show her graces best.
A white wench thralls me, so doth golden yellow,
And nut-brown girls in doing have no fellow.
If her white neck be shadowed with black hair,
Why so was Leda's, yet was Leda fair.
Amber-tress'd is she, then on the morn think I,
My love alludes to every history:
A young wench pleaseth, and an old is good,
This for her looks, that for her womanhood:
Nay what is she that any Roman loves,
But my ambitious ranging mind approves?

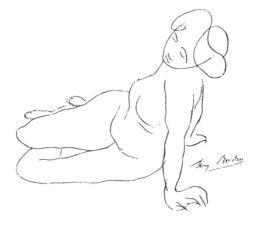

ELEGY 18

To his unfaithful mistress

No love is so dear (quiver'd Cupid, fly)
That my chief wish should be so oft to die.
Minding thy fault, with death I wish to revel,
Alas a wench is a perpetual evil.
No intercepted lines thy deeds display,
No gifts given secretly thy crime bewray.
O would my proofs as vain might be withstood,
Ay me, poor soul, why is my cause so good.
He's happy, that his love dares boldly credit,
To whom his wench can say, I never did it.
He's cruel, and too much his grief doth favour
That seeks the conquest by her loose behaviour.
Poor wretch, I saw when thou didst think I slumber'd,
Not drunk, your faults in the spilt wine I number'd.
I saw your nodding eyebrows much to speak,
Even from your cheeks part of a voice did break.
Not silent were thine eyes, the board with wine
Was scribbled, and thy fingers writ a line.
I knew your speech (what do not lovers see?)
And words that seem'd for certain marks to be.
Now many guests were gone, the feast being done,
The youthful sort to divers pastimes run.
I saw you then unlawful kisses join,
(Such with my tongue it likes me to purloin).
None such the sister gives her brother grave,
But such kind wenches let their lovers have.
Phœbus gave not Diana such 'tis thought,
But Venus often to her Mars such brought.
'What dost?', I cried, 'Transport'st thou my delight?

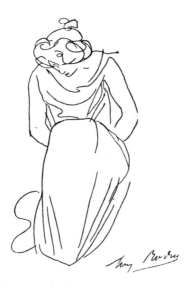

My lordly hands I'll throw upon my right.
Such bliss is only common to us two,
In this sweet good, why hath a third to do?
This, and what grief enforc'd me say I said,
A scarlet blush her guilty face arrayed.
Even such as by Aurora hath the sky,
Or maids that their betrothed husbands spy.
Such as a rose mixed with a lily breeds,
Or when the moon travels with charmed steeds.
Or such as, lest long years should turn the die,
Arachne stains Assyrian ivory.
To these, or some of these, like was her colour,
By chance her beauty never shined fuller.
She viewed the earth: the earth to view, beseem'd her.
She looked sad: sad, comely I esteem'd her.
Even kembed as they were, her locks to rend,
And scratch her fair soft cheeks I did intend.

Seeing her face, mine uprear'd arms descended,
With her own armour was my wench defended.
I that ere-while was fierce, now humbly sue,
Lest with worse kisses she should me endue.
She laugh'd, and kiss'd so sweetly as might make
Wrath-kindled Jove away his thunder shake.
I grieve lest others should such good perceive,
And wish hereby them all unknown to leave.
Also much better were they than I tell,
And ever seem'd as some new sweet befell.
'Tis ill they pleas'd so much, for in my lips,
Lay her whole tongue hid, mine in hers she dips.
This grieves me not, no joined kisses spent,
Bewail I only, though I them lament.
No where can they be taught but in the bed,
I know no master of so great hire sped.

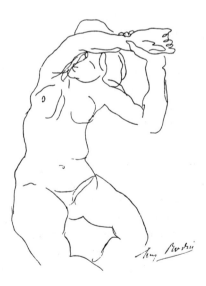

ELEGY 19

*He eclears himself of his mistress's accusation
that he loves her maid*

Dost me of new crimes always guilty frame?
To overcome, so oft to fight I shame.
If on the Marble Theatre I look,
One among many is to grieve thee took.
If some fair wench me secretly behold,
Thou arguest she doth secret marks unfold.
If I praise any, thy poor hairs thou tear'st,
If blame, dissembling of my fault thou fear'st.
If I look well, thou think'st thou dost not move,
If ill, thou say'st I die for others' love.
Would I were culpable of some offence,
They that deserve pain, bear 't with patience.
Now rash accusing, and thy vain belief,
Forbid thine anger to procure my grief.
Lo, how the miserable great-ear'd ass,
Dull'd with much beating slowly forth doth pass.
Behold Cypassis wont to dress thy head,
Is charg'd to violate her mistress' bed.
The gods from this sin rid me of suspicion,
To like a base wench of despis'd condition.
With Venus' game who will a servant grace?
Or any back made rough with stripes embrace?
Add, she was diligent thy locks to braid,
And for her skill to thee a grateful maid.
Should I solicit her that is so just
To take repulse, and cause her show my lust?
I swear by Venus, and the wing'd boy's bow,
My self unguilty of this crime I know.

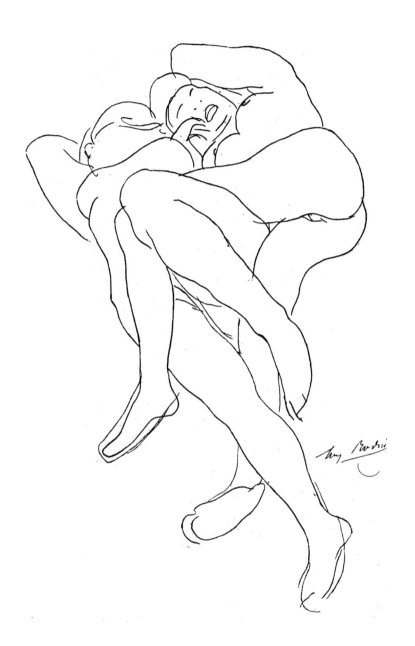

ELEGY 20

To his mistress, that if she sin,
she sin in secret

Seeing thou art fair, I bar not thy false playing,
But let not me poor soul know of thy straying.
Nor do I give thee counsel to live chaste,
But that thou would'st dissemble when 'tis past.
She hath not trod awry that doth deny it,
Such as confess, have lost their good names by it.
What madness is't to tell night pranks by day,
And hidden secrets openly to bewray?
The strumpet with the stranger will not do,
Before the room be clear, and door put to.
Will you make shipwreck of your honest name,
And let the world be witness of the same?
Be more advis'd, walk as a puritan,
And I shall think you chaste, do what you can.
Slip still, only deny it when 'tis done,
And before folk immodest speeches shun,
The bed is for lascivious toyings meet,
There use all tricks, and tread shame under feet.
When you are up and dress'd, be sage and grave,
And in the bed hide all the faults you have,
Be not ashamed to strip you being there,
And mingle thighs, yours ever mine to bear.
There in your rosy lips my tongue entomb,
Practise a thousand sports when there you come,
Forbear no wanton words you there would speak,
And with your pastime let the bedstead creak,
But with your robes, put on an honest face,
And blush, and seem as you were full of grace.

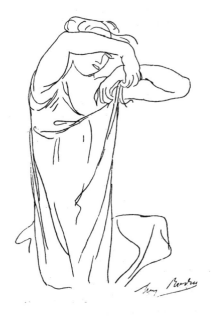

Deceive all, let me err, and think I'm right,
And like a wittol think thee void of sleight.
Why see I lines so oft receiv'd and given,
This bed, and that by tumbling made uneven,
Like one start up, your hair toss'd and displac'd,
And with a wanton's tooth, your neck new-rac'd?
Grant this, that what you do I may not see,
If you weigh not ill speeches, yet weigh me:
My soul fleets when I think what you have done,
And thorough every vein doth cold blood run,
Then thee whom I must love I hate in vain,
And would be dead, but dying with thee remain.
I'll not sift much, but hold thee soon excus'd,
Say but thou wert injuriously accus'd.
Though while the deed be doing you be took,
And I see when you ope the two-leaved book:

Swear I was blind, yield not, if you be wise,
And I will trust your words more than mine eyes.
From him that yields, the garland is quickly got,
Teach but your tongue to say, I did it not,
And being justified by two words, think
The cause acquits you not, but I that wink.

*He complains that, being admitted by his mistress,
he couldn't copulate*

Either she was foul, or her attire was bad,
Or she was not the wench I wish'd t'have had.
Idly I lay with her, as if I lov'd not,
And like a burden griev'd the bed that mov'd not.
Though both of us perform'd our true intent,
Yet could I not cast anchor where I meant,
She on my neck her ivory arms did throw,
That were as white as is the Scythian snow,
And eagerly she kiss'd me with her tongue,
And under mine her wanton thigh she flung,
Yea, and she sooth'd me up, and call'd me 'Sir',
And used all speech that might provoke and stir.
Yet like as if cold hemlock I had drunk,
It mocked me, hung down the head, and sunk,
Like a dull cipher, or rude block I lay,
Or shade, or body was I, who can say?
What will my age do, age I cannot shun,
Seeing in my prime my force is spent and done?

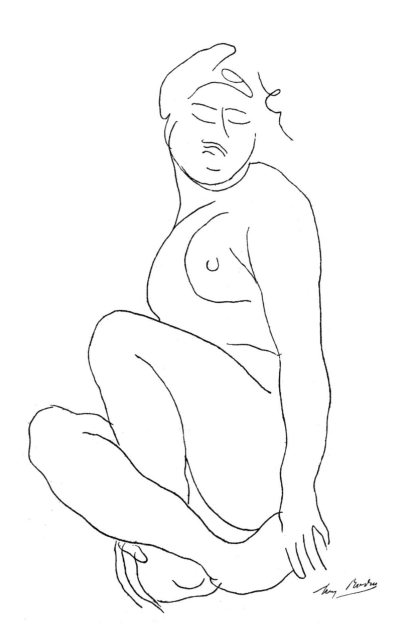

I blush, that being youthful, hot, and lusty,
I prove neither youth nor man, but old and rusty.
Pure rose she, like a nun to sacrifice,
Or one that with her tender brother lies,
Yet boarded I the golden city twice,
And Libas, and the white cheek'd Pitho thrice,
Corinna crav'd it in a summer's night,
And nine sweet bouts had we before daylight.
What, waste my limbs through some Thessalian charms
May spells and drugs do silly souls such harms?
With virgin wax hath some imbas'd my joints,
And pierc'd my liver with sharp needle points?
Charms change corn to grass, and makes it die,
By charms are running springs and fountains dry,
By charms mast drops from oaks, from vines grapes fall,
And fruit from trees, when there's no wind at all.
Why might not then my sinews be enchanted,
And I grow faint, as with some spirit haunted?
To this add shame; shame to perform, it quail'd me,
And was the second cause why vigour fail'd me:
My idle thoughts delighted her no more
Than did the robe or garment which she wore,
Yet might her touch make youthful Pilius fire,
And Tithon livelier than his years require.
Even her I had, and she had me in vain,
What might I crave more if I ask again?
I think the great gods grieved they had bestowed
This benefit, which lewdly I forslow'd:
I wished to be receiv'd in, in I get me;
To kiss, I kiss, to lie with her she let me.
Why was I blest? Why made king to refuse it?
Chuff-like had I not gold, and could not use it?
So in a spring thrives he that told so much,

And looks upon the fruits he cannot touch.
Hath any rose so from a fresh young maid,
As she might straight have gone to church and pray'd?
Well, I believe she kiss'd not as she should,
Nor used the sleight nor cunning which she could,
Huge oaks, hard adamants might she have mov'd,
And with sweet words cause deaf rocks to have lov'd.
Worthy she was to move both gods and men,
But neither was I man, nor lived then.
Can deaf ears take delight when Phemius sings,
Or Thamyris in curious-painted things?
What sweet thought is there but I had the same?
And one gave place still as another came.
Yet notwithstanding, like one dead it lay,
Drooping more than a rose pull'd yesterday:

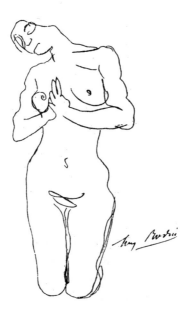

Now when he should not jet, he bolts upright,
And craves his task, and seeks to be at fight.
Lie down with shame, and see thou stir no more,
Seeing now thou would'st deceive me as before:
Thou cozenest me, by thee surpris'd am I,
And bide sore loss, with endless infamy.
Nay more, the wench did not disdain a whit,
To take it in her hand and play with it.
But when she saw it would by no means stand,
But still droop'd down, regarding not her hand,
'Why mock'st thou me?' she cried, 'Or being ill,
Who bade thee lie down here against thy will?
Either th'art witch'd with blood of frogs new dead,
Or jaded cam'st thou from some other's bed!'
With that her loose gown on, from me she cast her,
In skipping out her naked feet much grac'd her.
And lest her maid should know of this disgrace,
To cover it, spilt water in the place.

ELEGY 22

*To Venus, that he is bringing
the elegies to an end*

Tender Love's mother, a new poet get,
This last end to my elegies is set,
Which I Peligny's foster-child have fram'd,
(Nor am I by such wanton toys defam'd)
Heir of an ancient house, if help that can,
Not only by war's rage made gentleman.

In Virgil Mantua joys: in Catul Verone,
Of me Peligny's nation boasts alone,
Whom liberty to honest arms compell'd,
When careful Rome in doubt their prowess held.
And some guest viewing wat'ry Sulmo's walls,
Where little ground to be enclos'd befalls,
'How such a poet could you bring forth', says,
'How small soe'er, I'll you for greatest praise'.
Both loves to whom my heart long time did yield,
Your golden ensigns pluck out of my field,
Horn'd Bacchus' graver fury doth distil,
A greater ground with great horse is to till.
Weak elegies, delightful Muse, farewell;
A work, that after my death, here shall dwell.

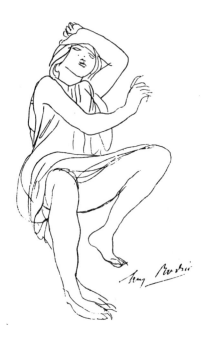

First published 2006
This edition published 2018 by
Pallas Athene (Publishers) Limited
Studio 11A, Archway Studios, 25-27 Bickerton Road, London N19 5JT
www.pallasathene.co.uk
© Pallas Athene 2006, 2018
ISBN 978 1 84368 163 2

TEXTUAL NOTE

Rodin's formal education was very limited, but his favourite authors were very close to him, and few more so than Ovid.
He had planned for many years to produce an illustrated edition of the Elegies, using woodcuts based on his life drawings, but the project was not completed until 1935, sixteen years after his death, with the appearance of a hand-printed volume published by his long-term collaborators.

The translation used to accompany Rodin's images was a typical example of the poetry of France's Grand Siècle, the seventeenth century. By analogy, we have chosen the translation into heroic couplets written by the brash young Christopher Marlowe while he was still an undergraduate at Cambridge.

This, one of the first great productions of the golden age of English verse, was published shortly after Marlowe's murder. It was banned by the Archbishop of Canterbury as 'unsemely' and copies were ceremonially burnt.

As far as is possible, Rodin's illustrations have been reproduced in the same position in the text. The idiosyncratic sequence of elegies has also been followed: Elegies 14 and 15 of Book One are omitted, as are Elegies 6 and 8-19 of Book Two, and Elegies 1-5 and 7-12 of Book Three.

@Pallasathenebooks
@Pallas_Books
@Pallasathenebooks
@Pallasathene

Printed in England